PRESIDENT'S NOTES

In a world of waste, we've decided to further our carbon neutrality. In the past, tons of our fellow print publishers have had to rerun an issue for a myriad of reasons. Now, we are in a web realm of decentralization and autonomy, and innovative ideas must reign supreme if we won't increase the earth's life expectancy.

For almost a decade, 360® has had no choice but to become more resourceful and attain the unachievable. Instead of taking on disgruntled workers, our new directives are aimed towards inclusivity and working in tandem with disadvantaged business enterprises who mirror our multi-hyphenate lifestyle. It's been too long that the complexity of our human lives have impacted our pages. Thus, we wanted to reintroduce our readers to the full page bleeds, allowing our supporters to better experience the art. To give our team once again the opportunity to reintegrate consumer touch points into one circle of solidarity. We humbly listened and introduced QR code pages which lead to stories. In a fast paced society, these stories that once had a shelf life can be updated within seconds using a robust expansive VPS, firewalls to protect your privacy and seamless interaction between your mobile device and this book. Lay on your stomach, let the pictures do the talking rather than unimaginative authors straying with words. If you need a tale, it's only a click away. After all, we may cover breaking news, but we all could use a form of escapism.

President × Editorial Director / Vaughn Lowery
Trademark Attorney / Linda Joy Kattwinkel, Esq.
Global Business Manager / Rodney Ramlochan
Art Director / Edwin De León
Culture Editor / Tom Wilmer
Lifestyle Editor / Patrick T. Cooper
Latinx Editor / Javier Pedroza
Creative / Armon Hayes
Auto Editor / Shin Takei
Managing Editor / Krishan Narsinghani
Auto Contributors / Anthony Sovinsky, Benjamin Reese
Fashion Director / Marc Littlejohn
Fashion Contributors / Jamison Harris, Jonta Harris
Interior Design Contributor / Justin Lowery Osborne
Wine × Spirits Editor / Ilona Thompson
Copy Editors / Elle Grant, Hannah DiPilato
Special Assignments / Cameron Parkes, Kai Yeo, Tony Woods
Contributing Photographers / Jones Crow, Owen Duckett, Elton Anderson, Jeffrey Langlois
Digital × Marketing Coordinators / Fidely Felisse, Alexandra Quintero, Diana Macaraeg, Betsy Mendoza, Tiffani Gipson, Kasia Widera, Hannah Audrey Lowe, Iris Li, Lana Heaney, Andrea Esteban, Jacqueline Alvarez, Hu Die
Illustrators / Wanny NG, Nandini Kuppa-Apte
Layout Graphic Designer / Art Dept
Cover Photographer / Vaughn Lowery
Cover Location / BODEGA
360® MAG Podcast Hosts / Vaughn Lowery, LaJune Grant, Andre Dash, Armon Hayes, Javier Pedroza

LA
2219 Main St
Santa Monica, CA 90405
la@the360mag.com
+12138411841

NY
460 E Fordham Rd
Bronx, NY 10458
ny@the360mag.com

DALLAS
2149 San Simeon
Dallas, TX 75006
dallas@the360mag.com

LONDON
323 Sansom Rd
London Leytonstone E11 3HQ
london@the360mag.com

nglcc
Certified LGBTBE®

HQ
30 N Gould St
Sheridan, WY 82801
wy@the360mag.com

PARIS
8 Rue Baudelique 75018
Paris, France
paris@the360mag.com

CHICAGO
chicago@the360mag.
MIAMI
miami@the360mag.com

JAPAN
japan@the360mag.com
SOUTH AFRICA
sa@the360mag.com

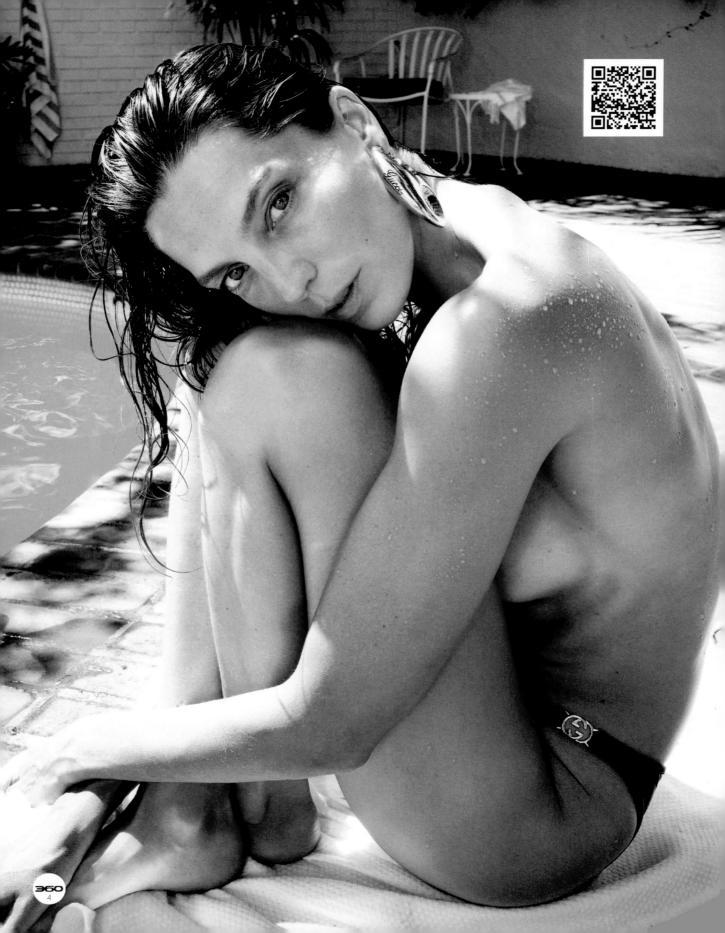

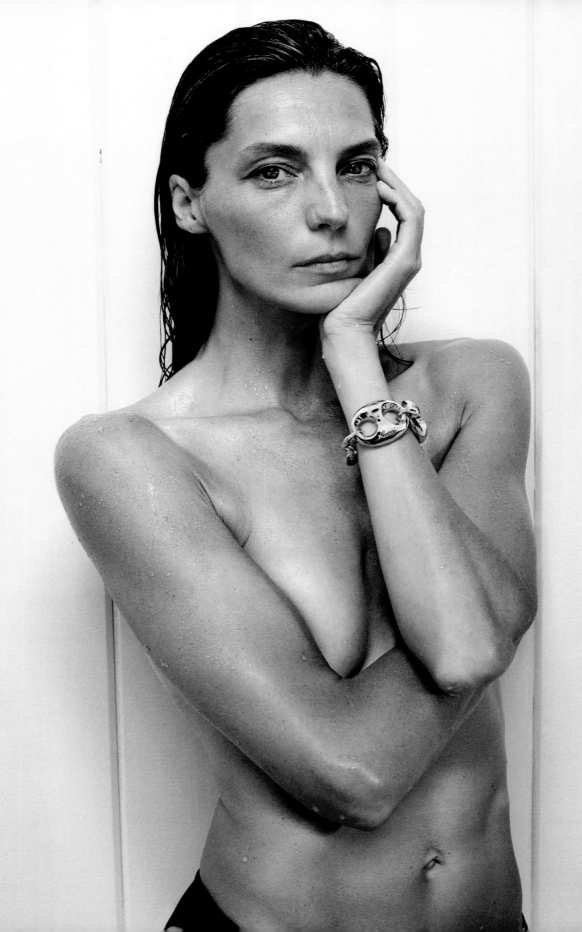

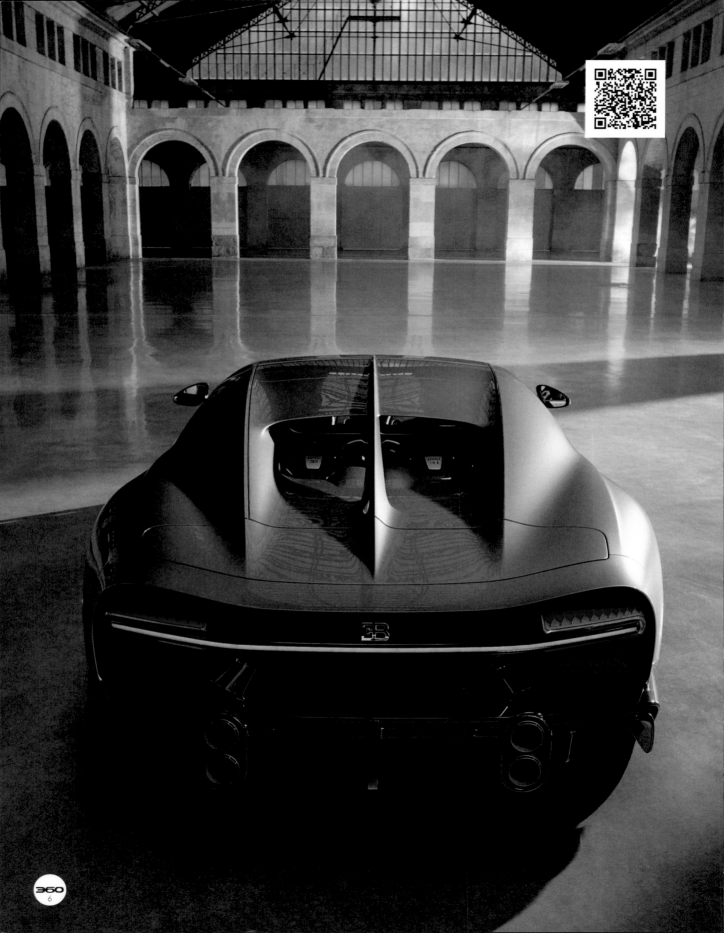

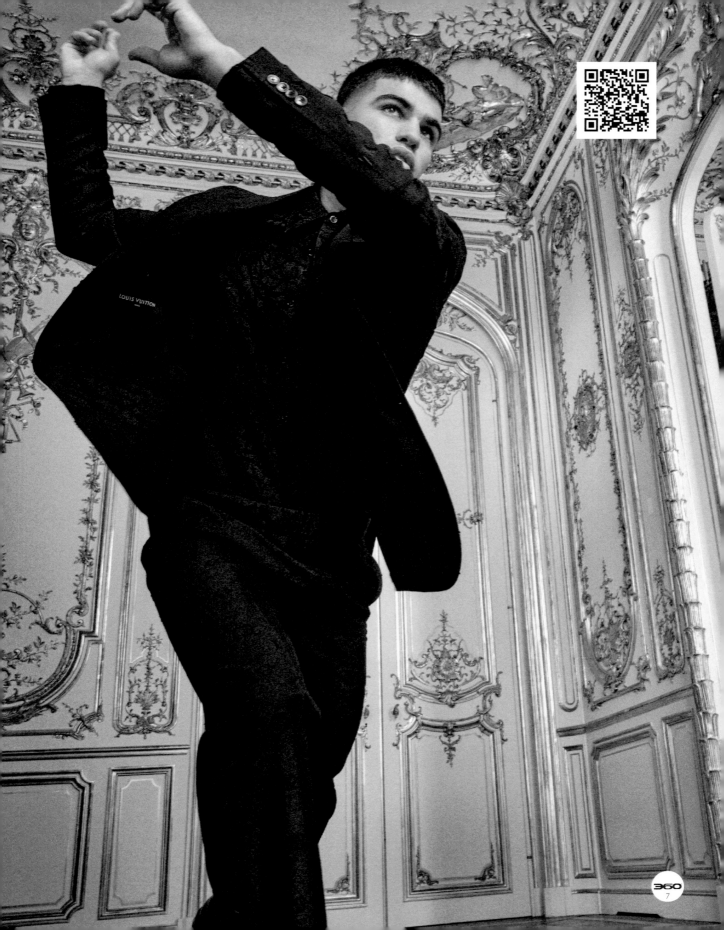

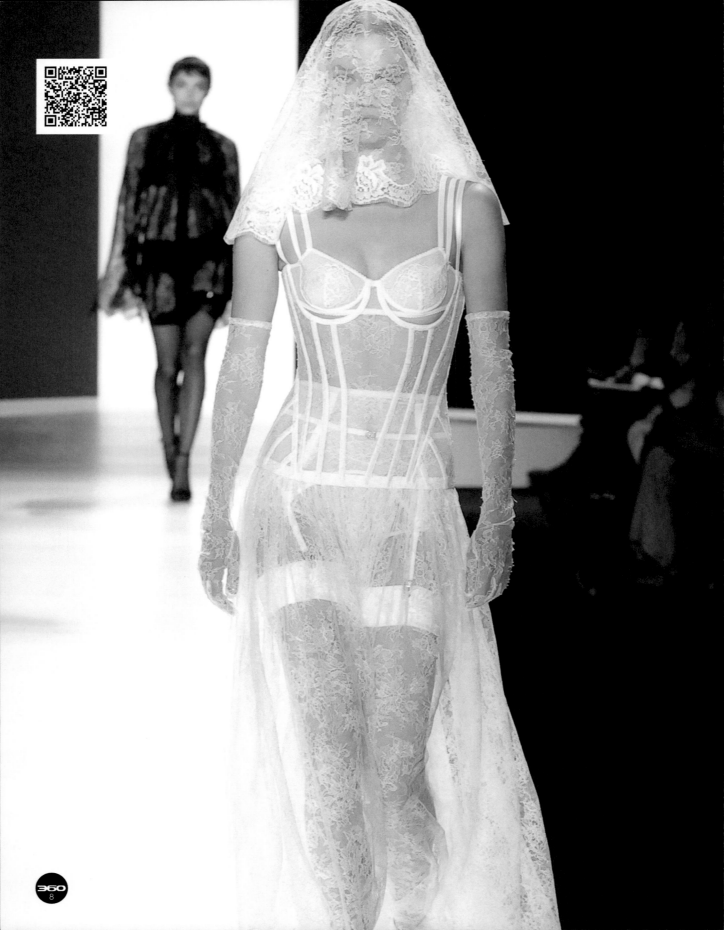

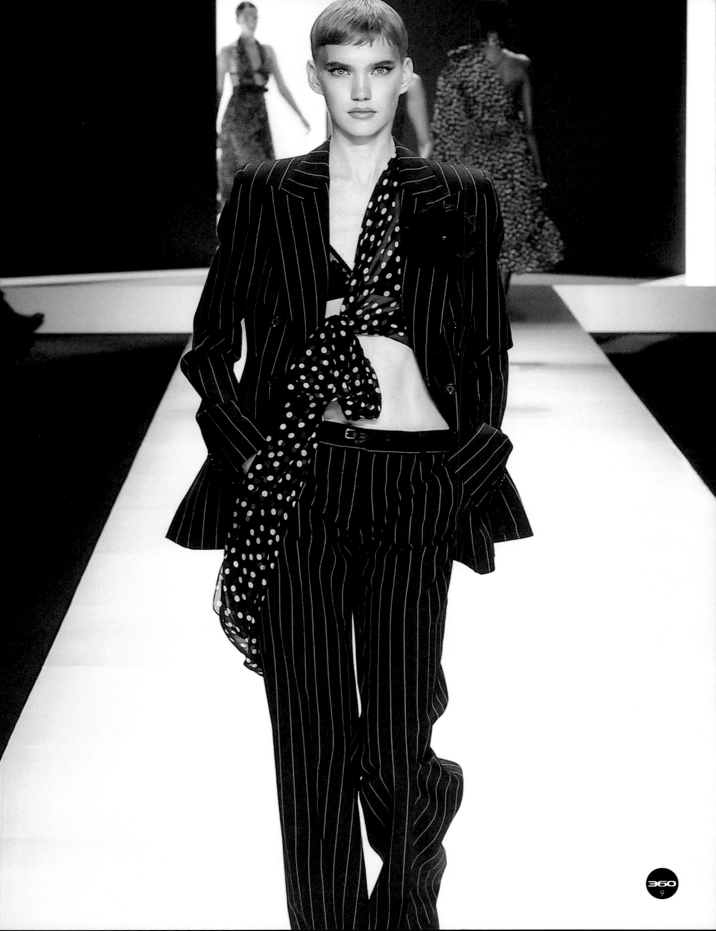

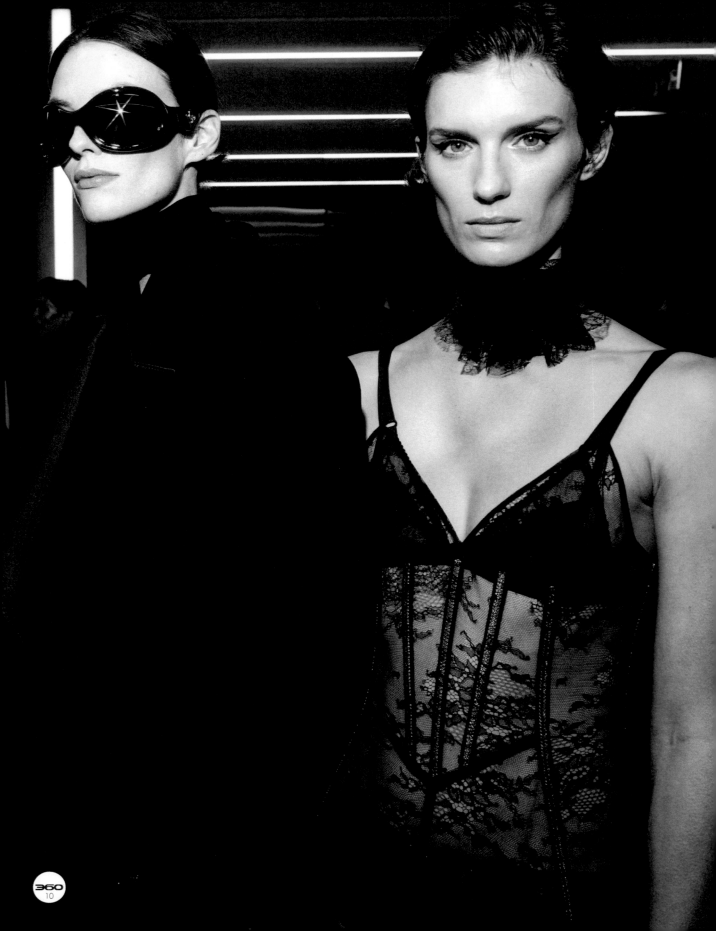

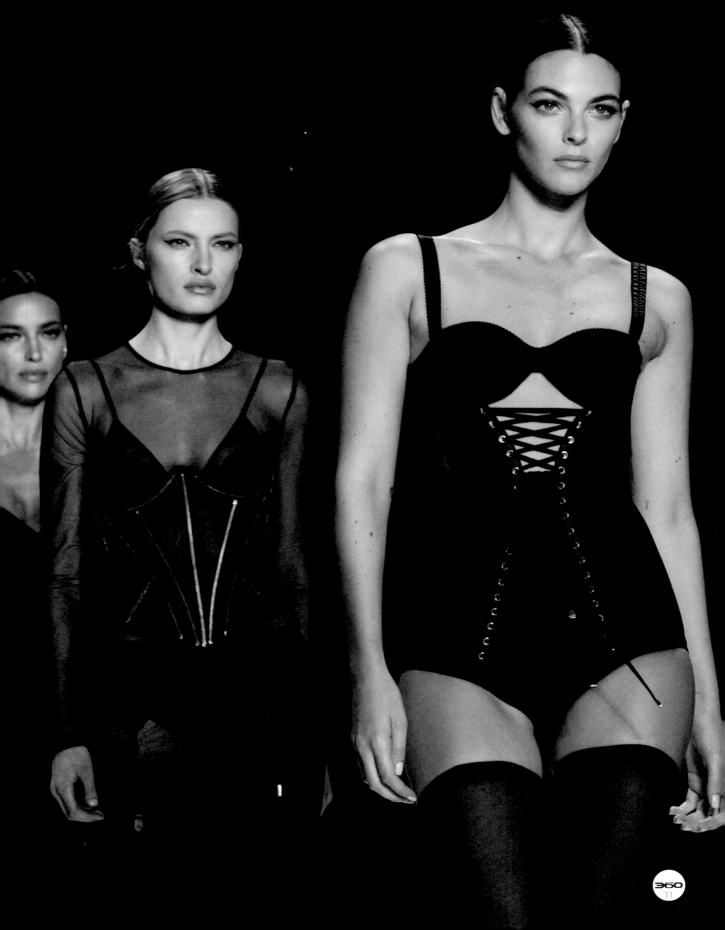

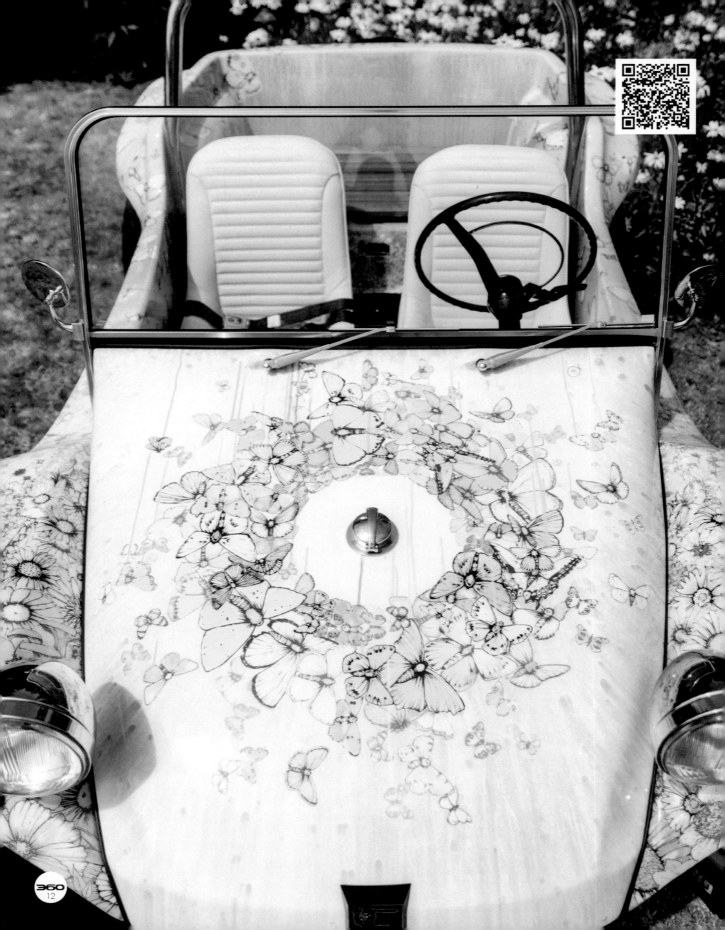

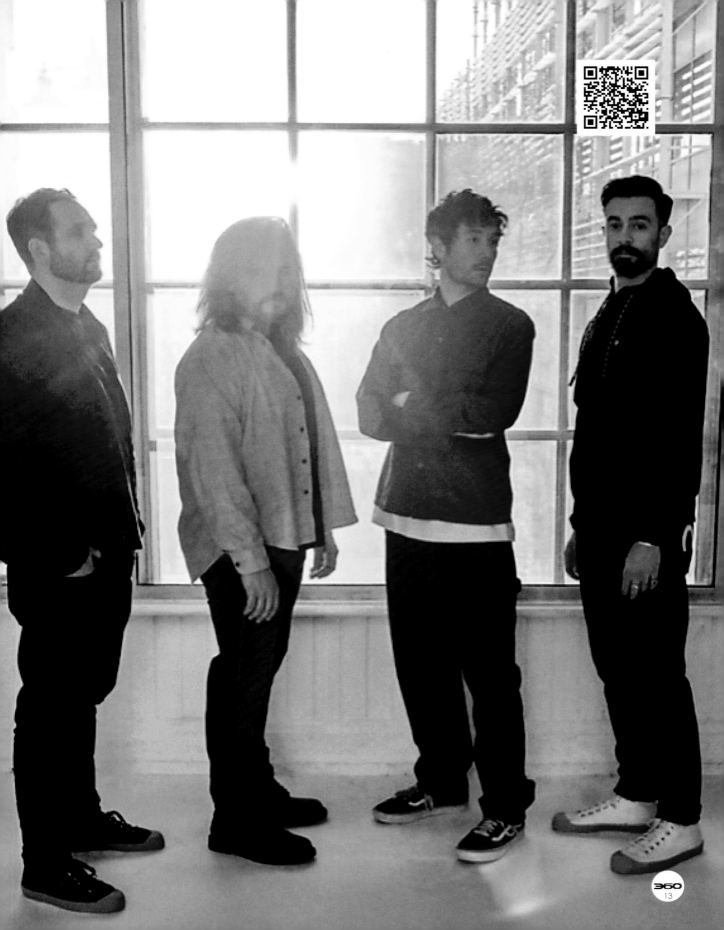

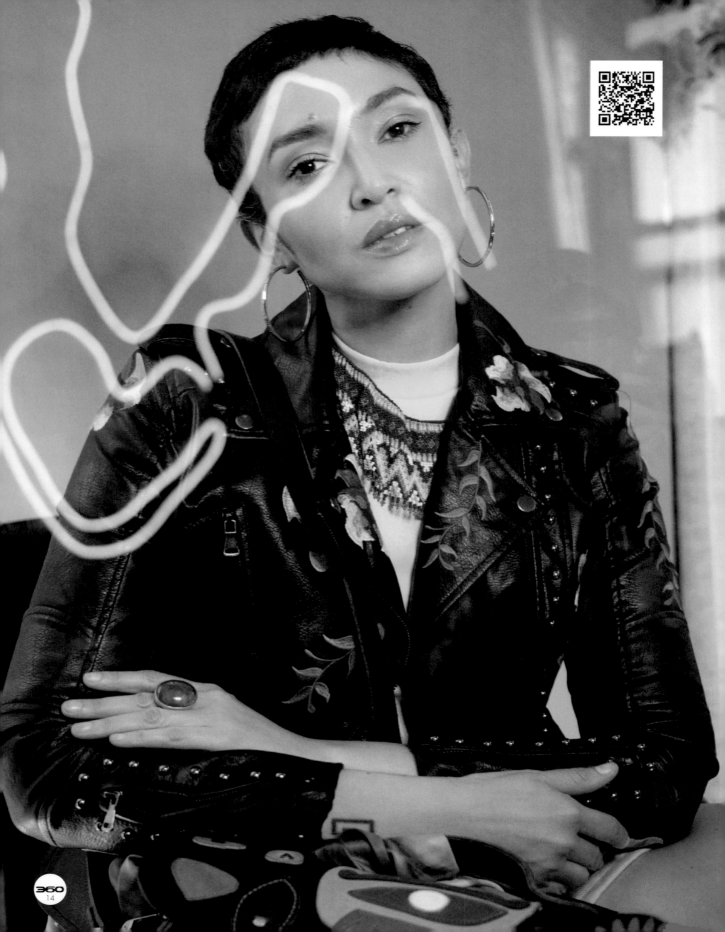

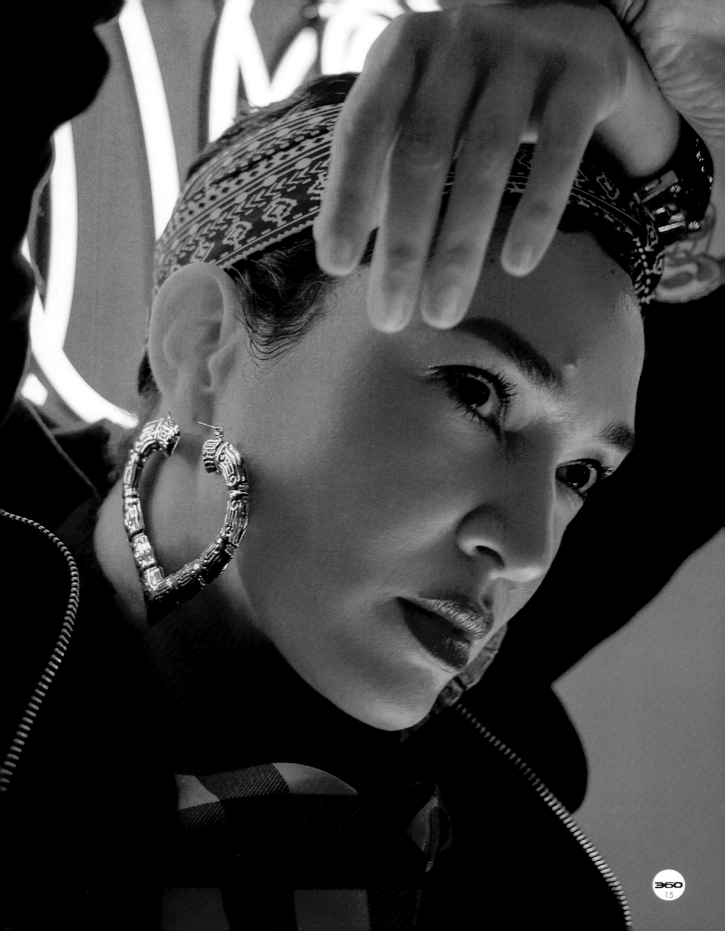

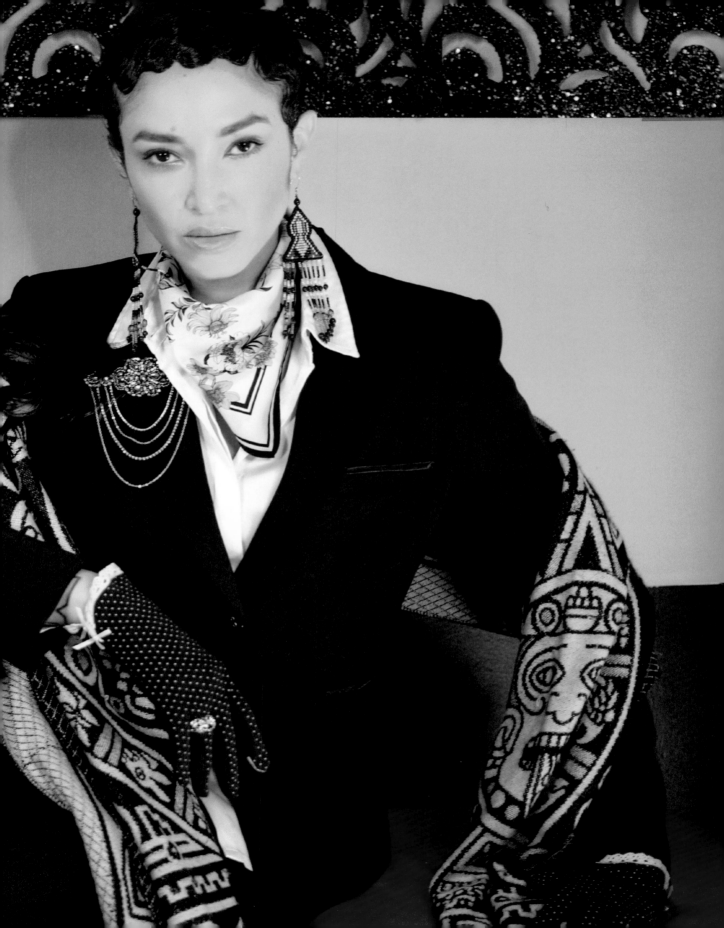

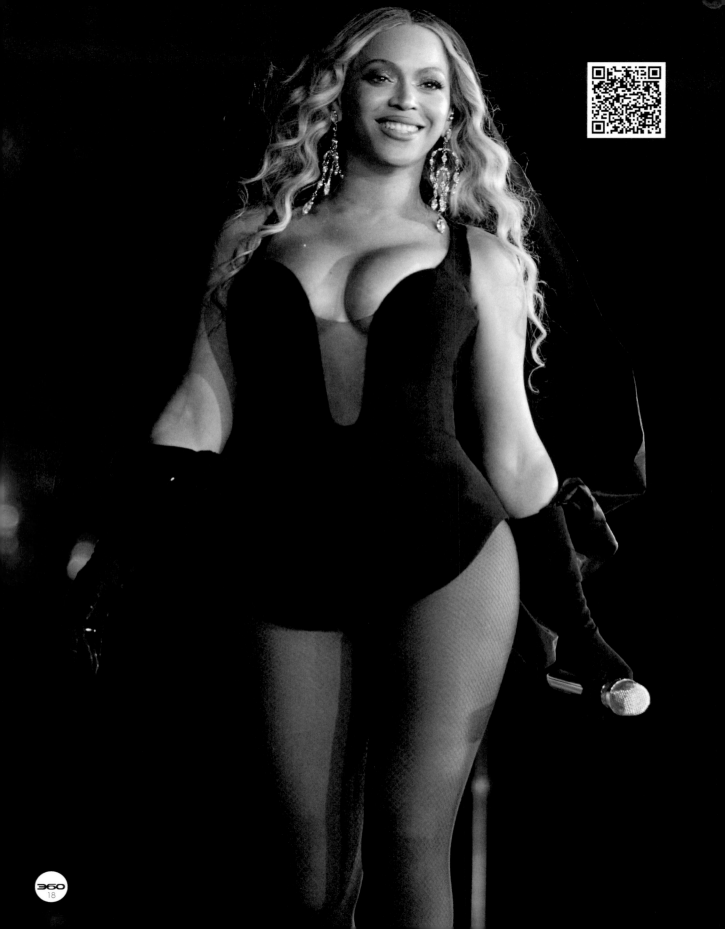

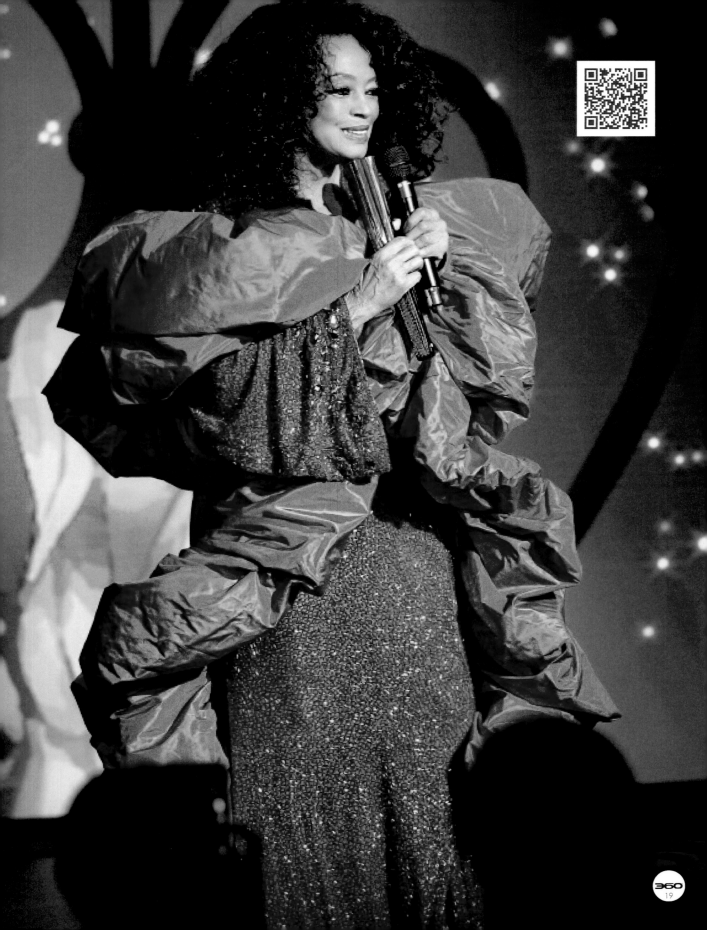

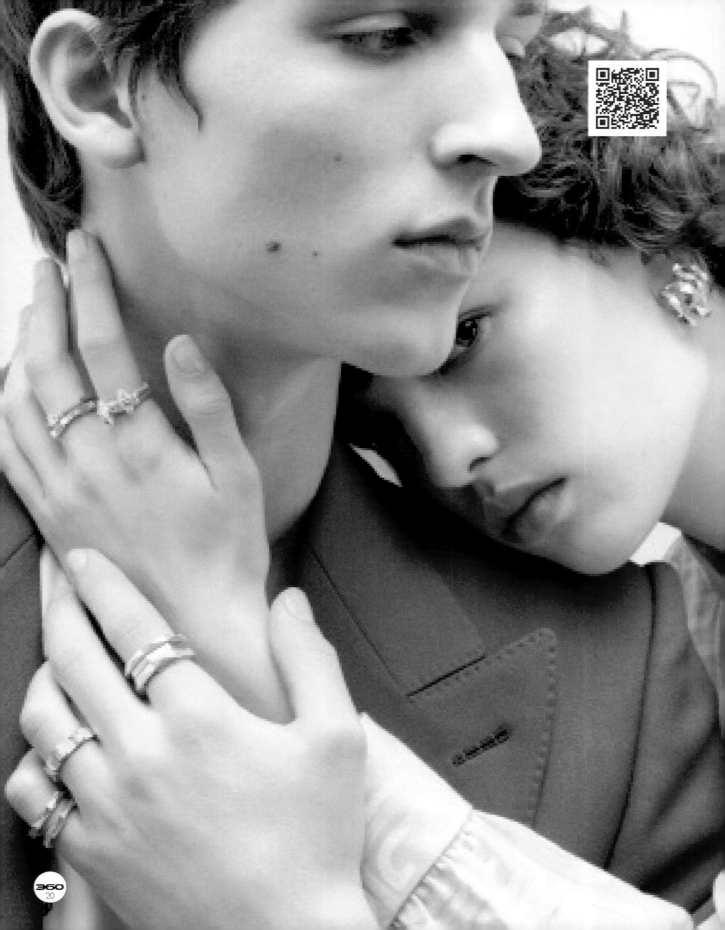

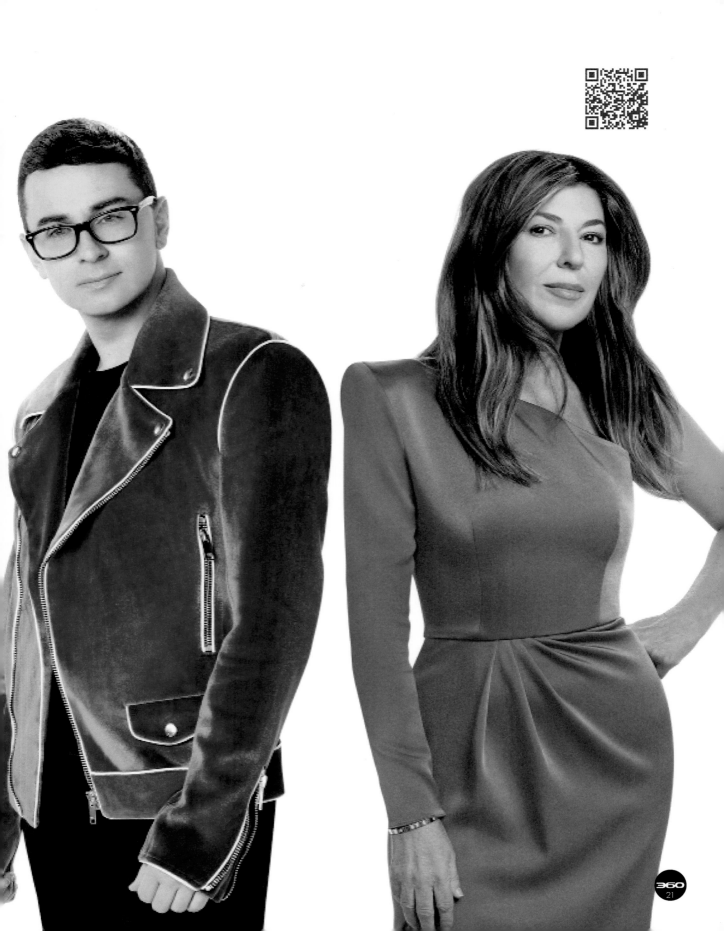

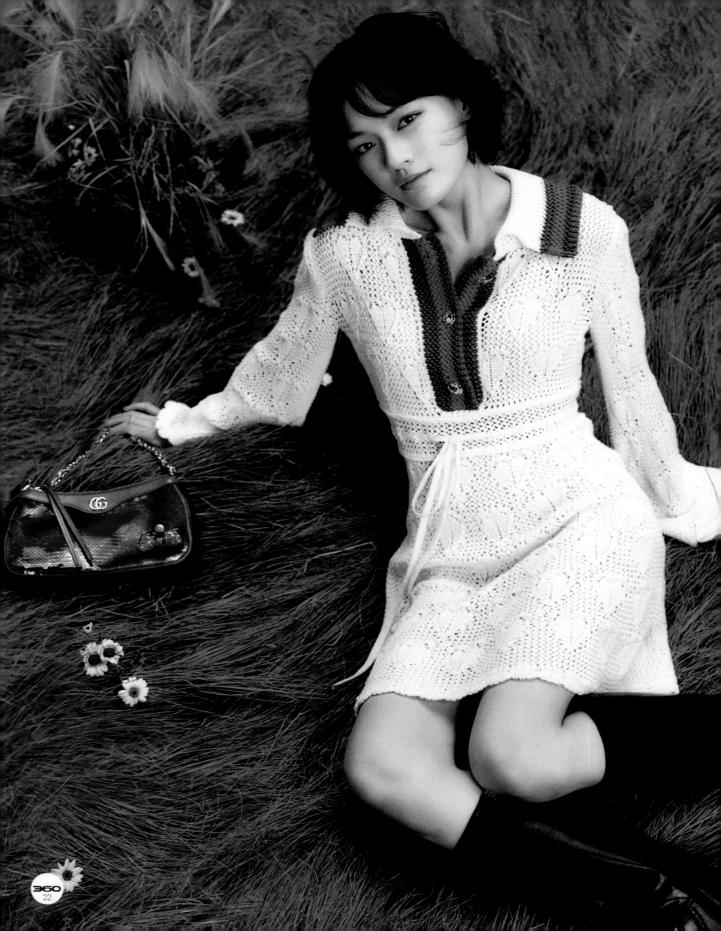

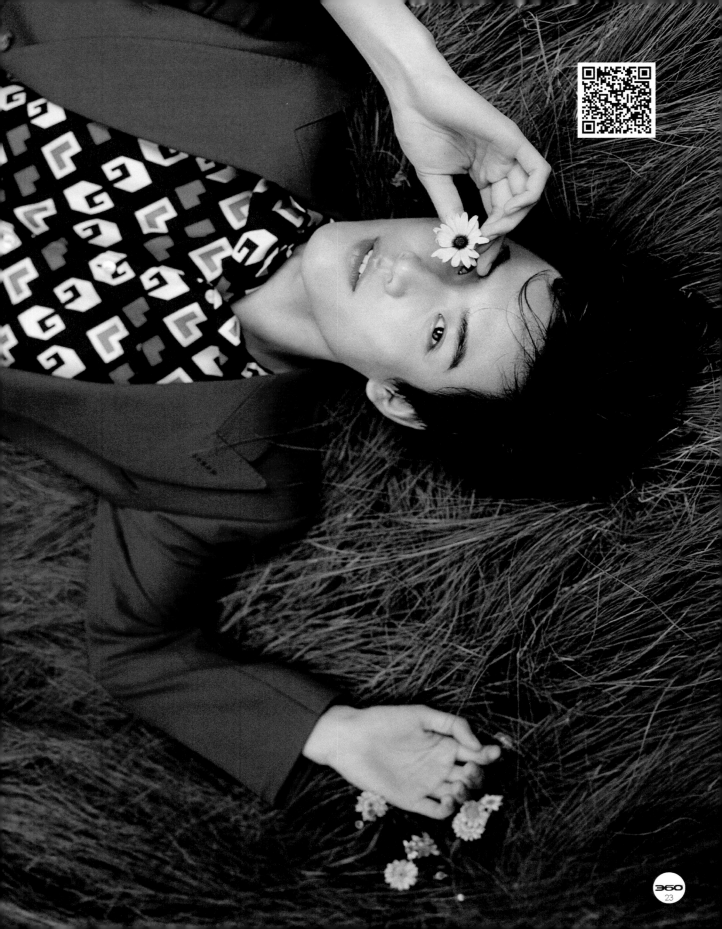

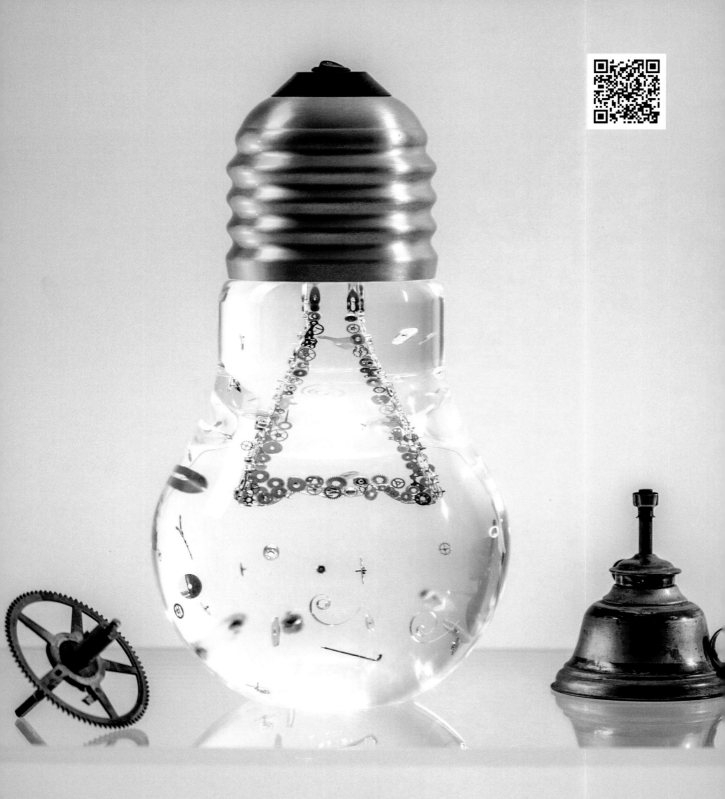

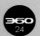

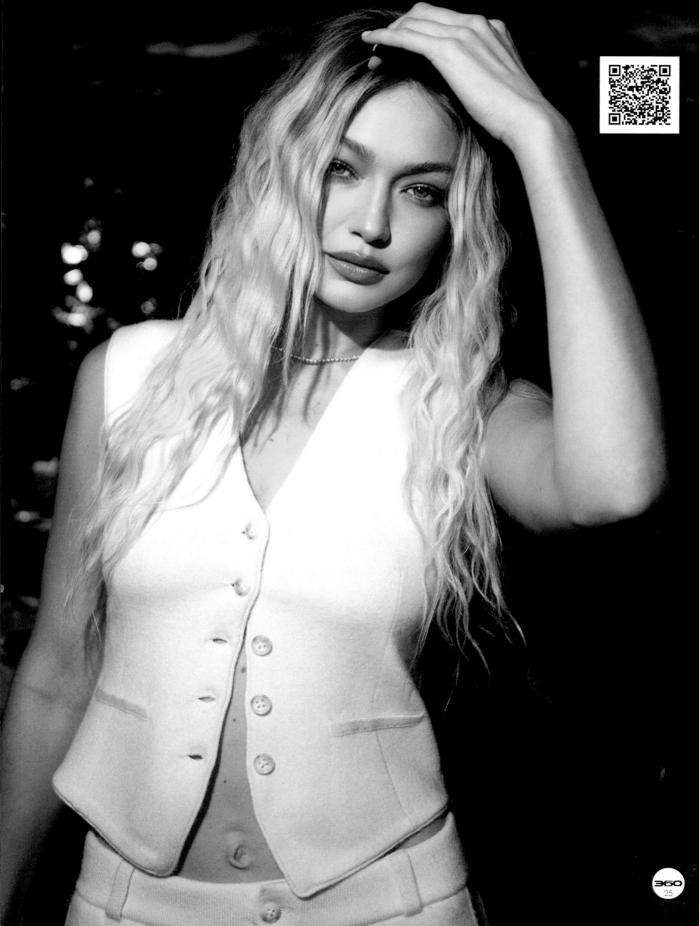

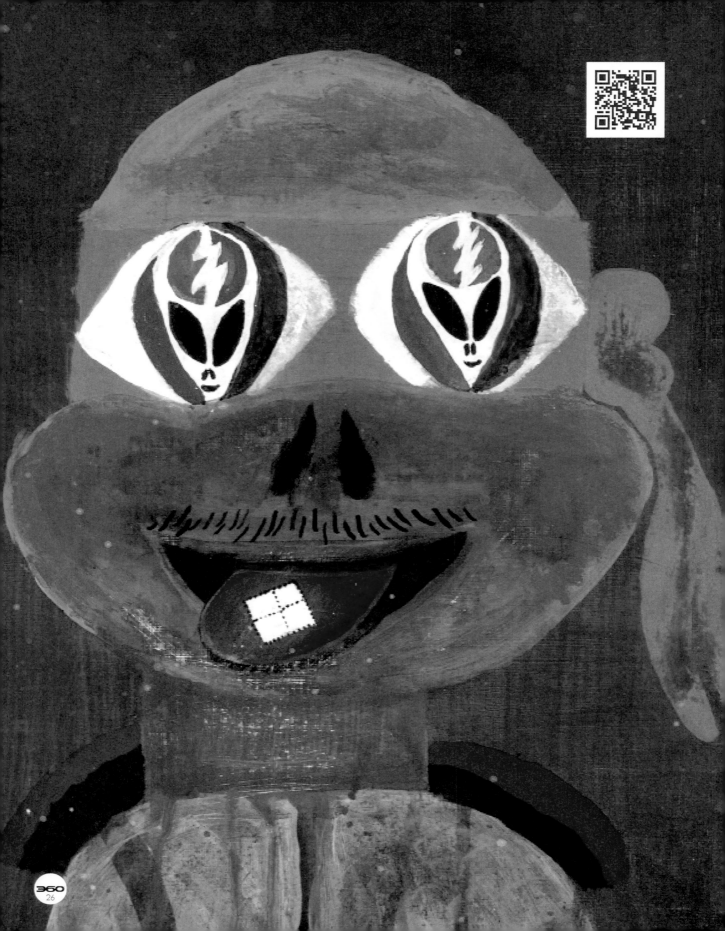

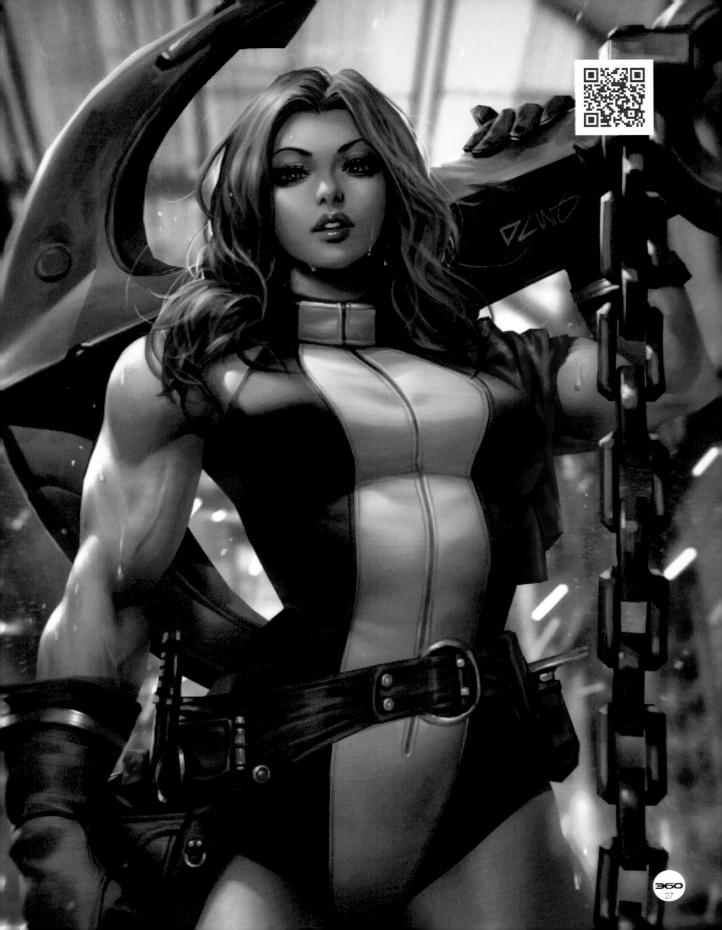

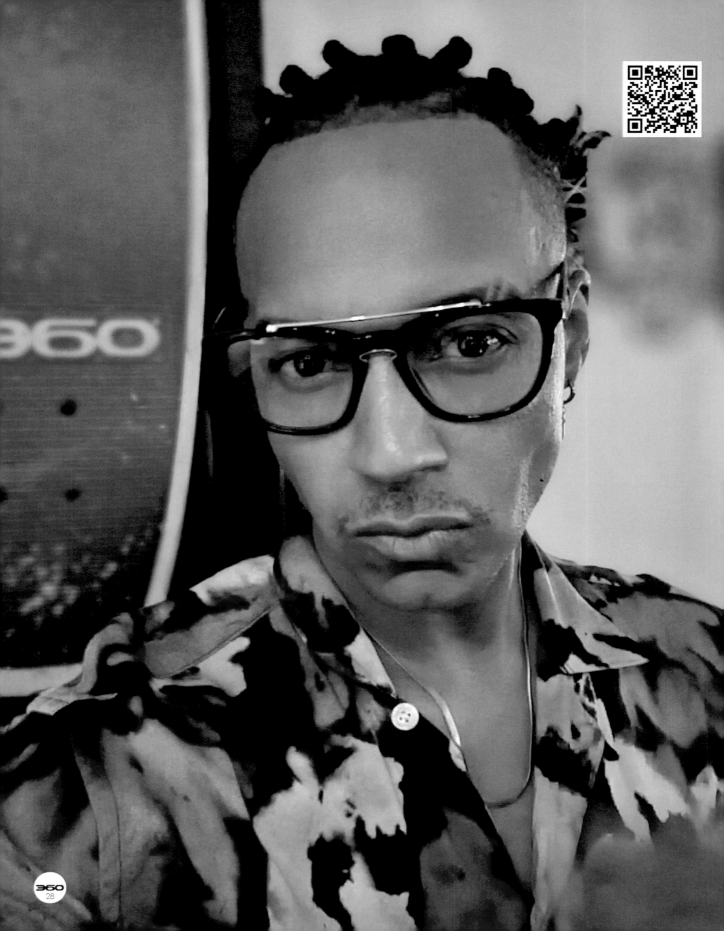

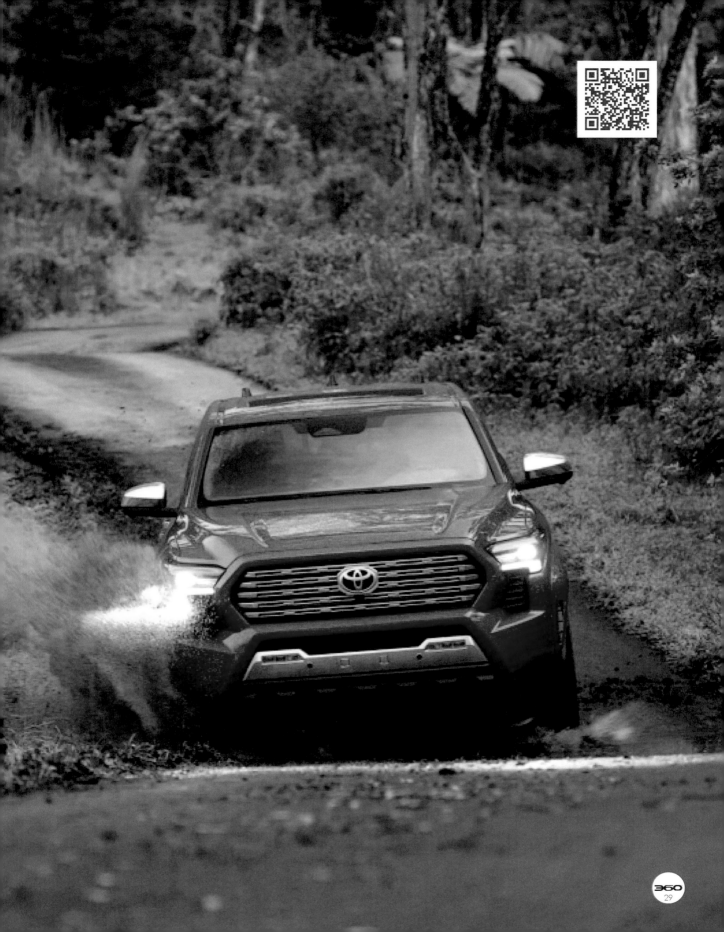

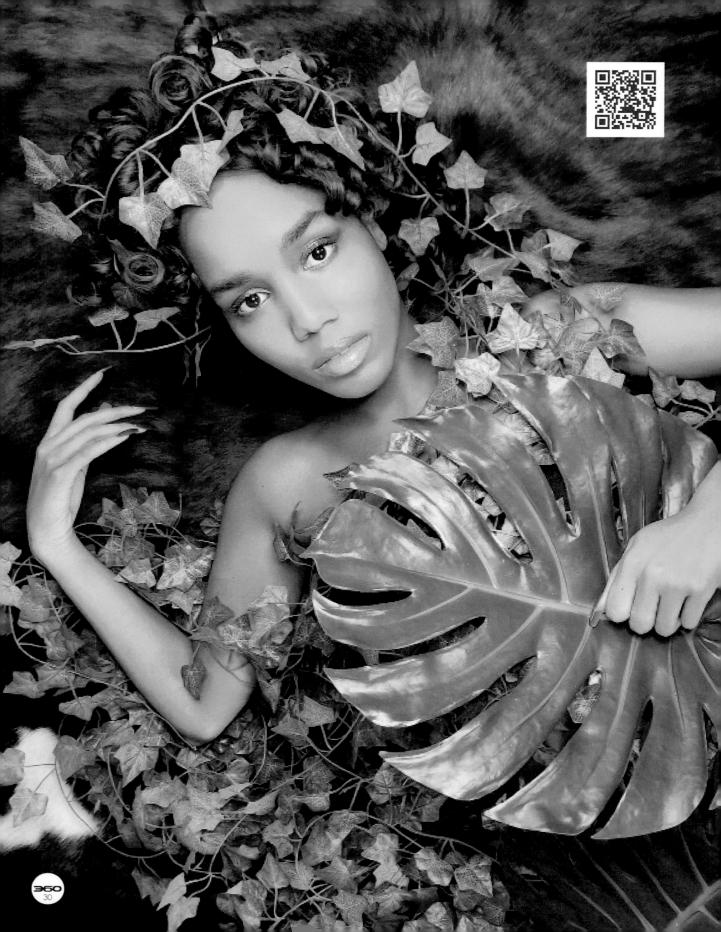

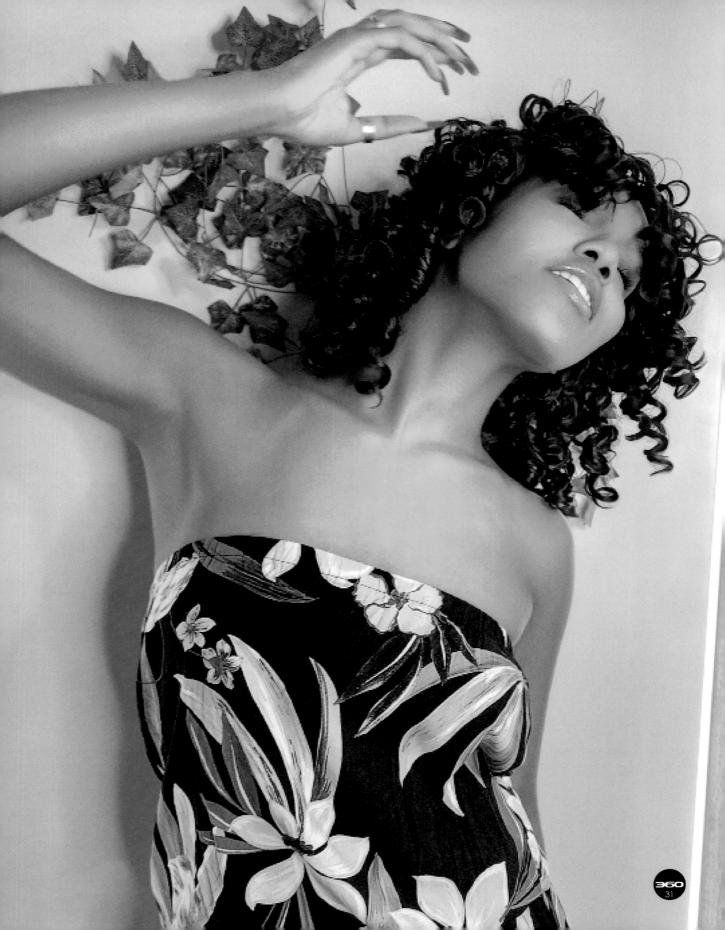

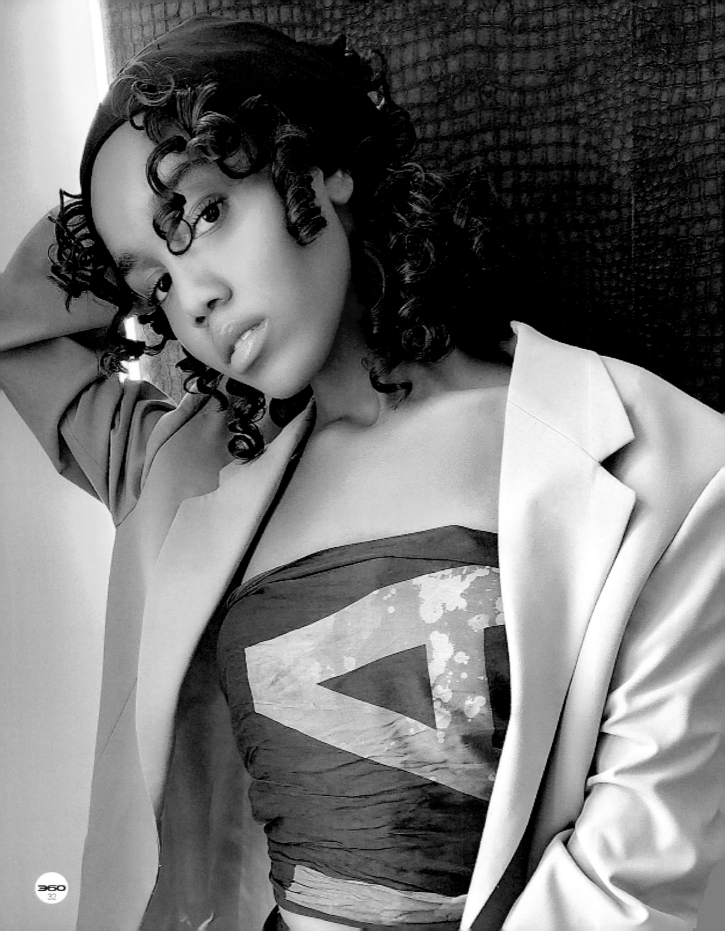

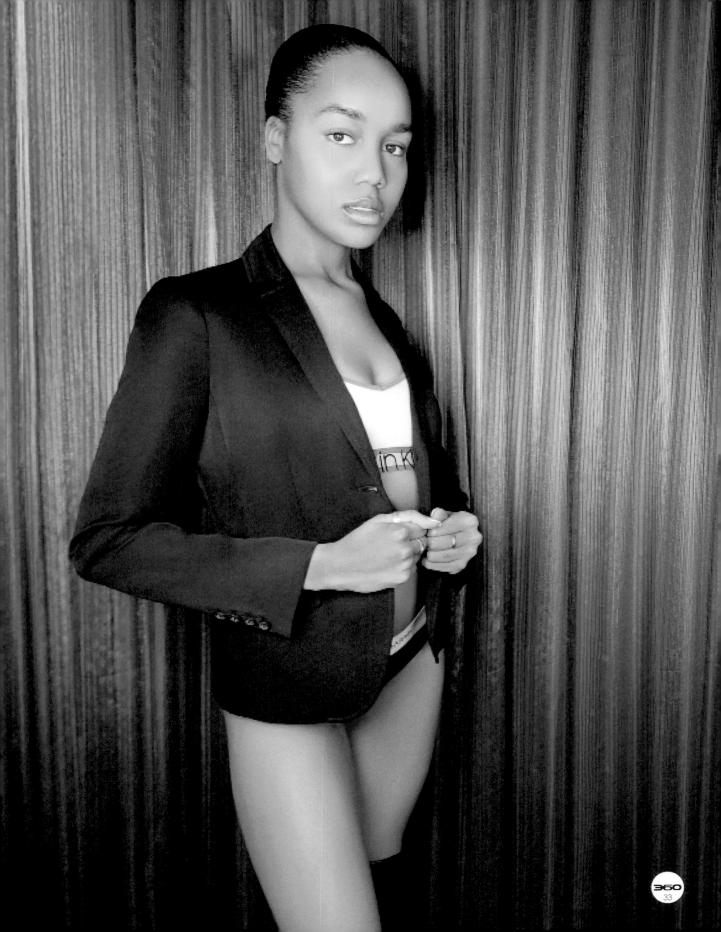

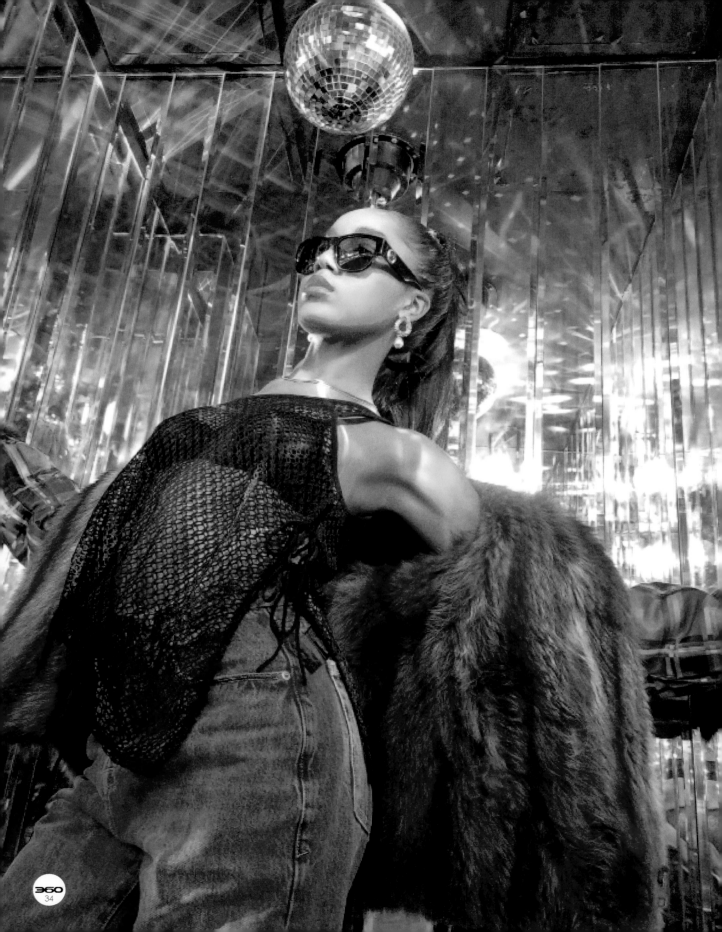

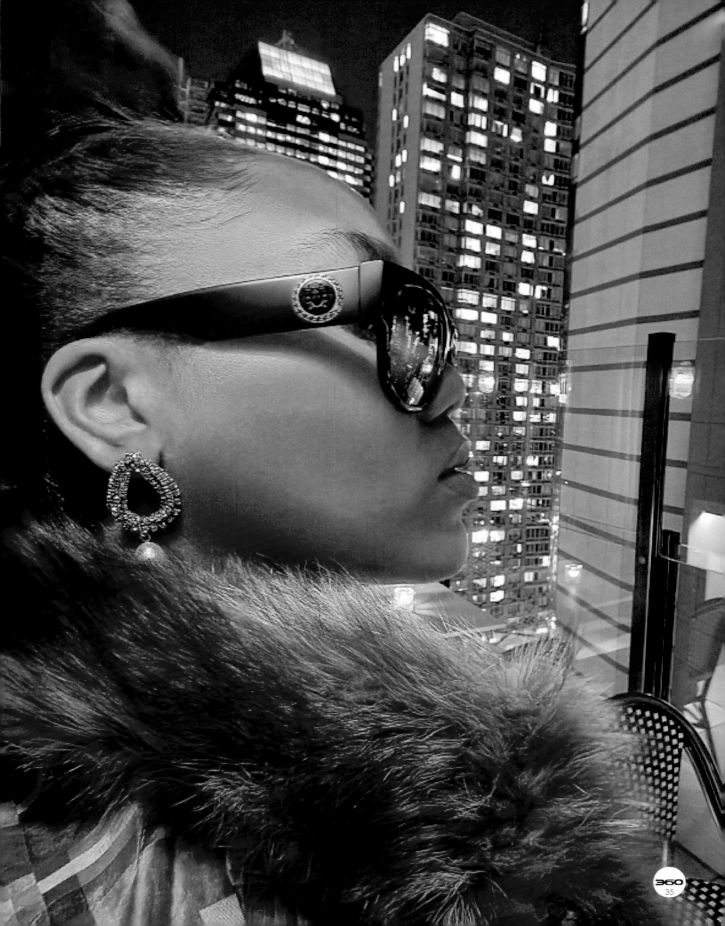

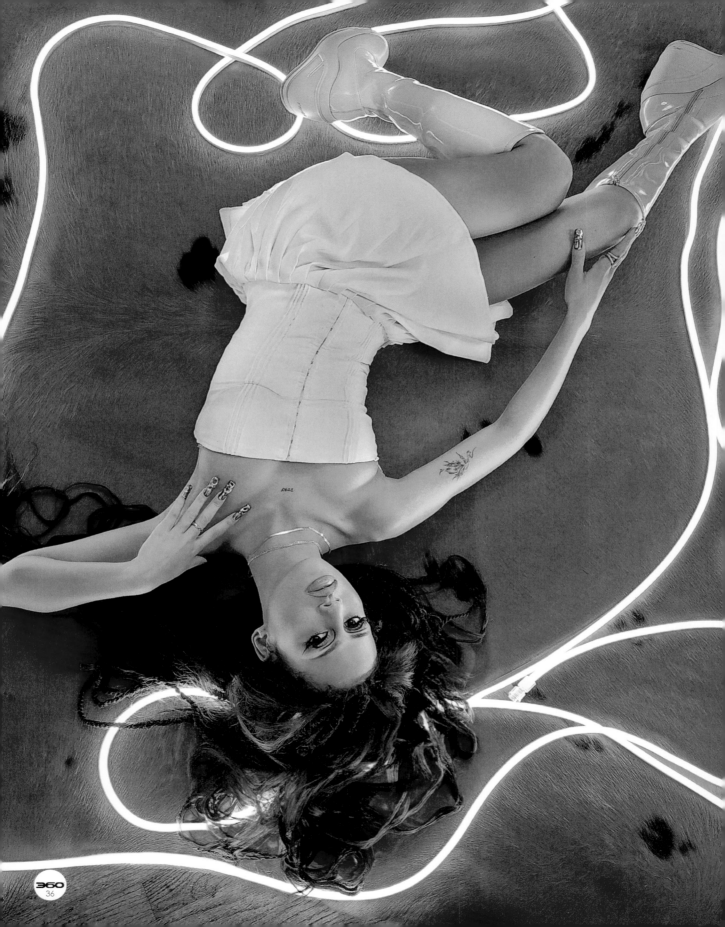

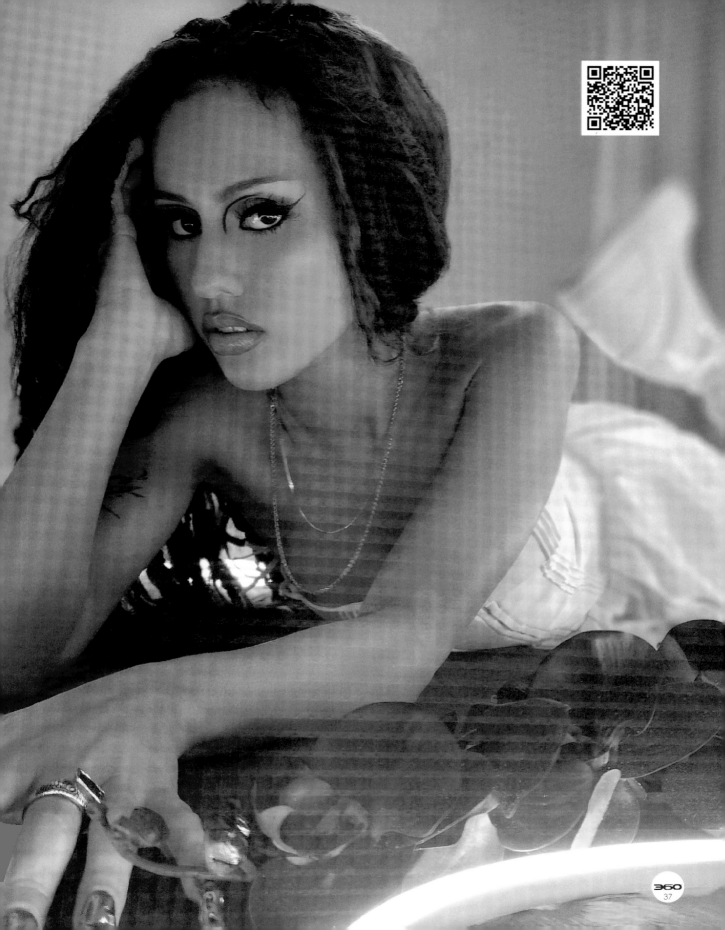

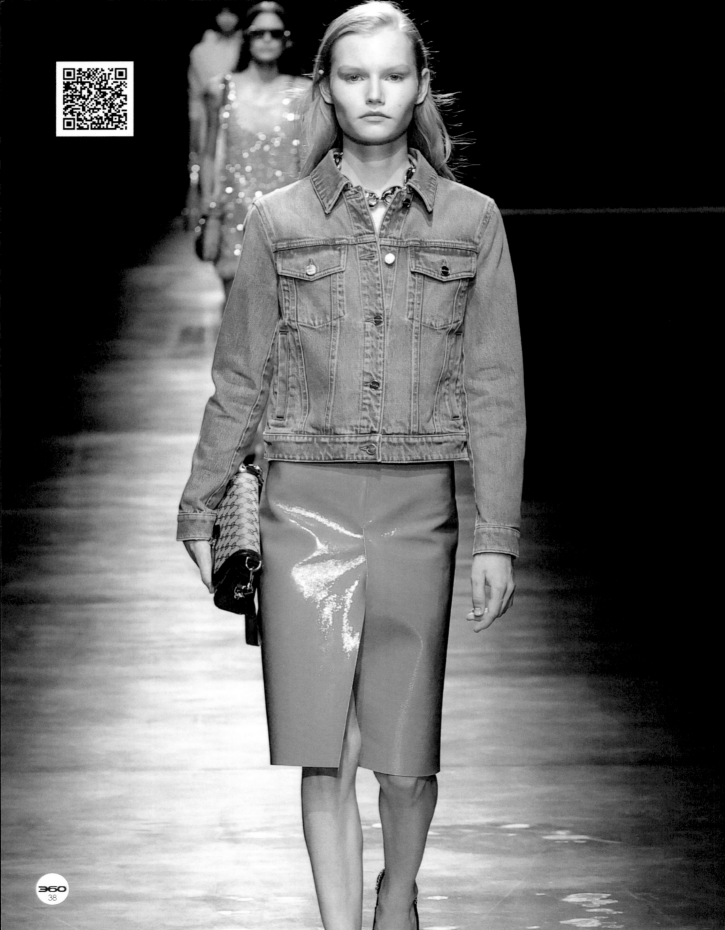

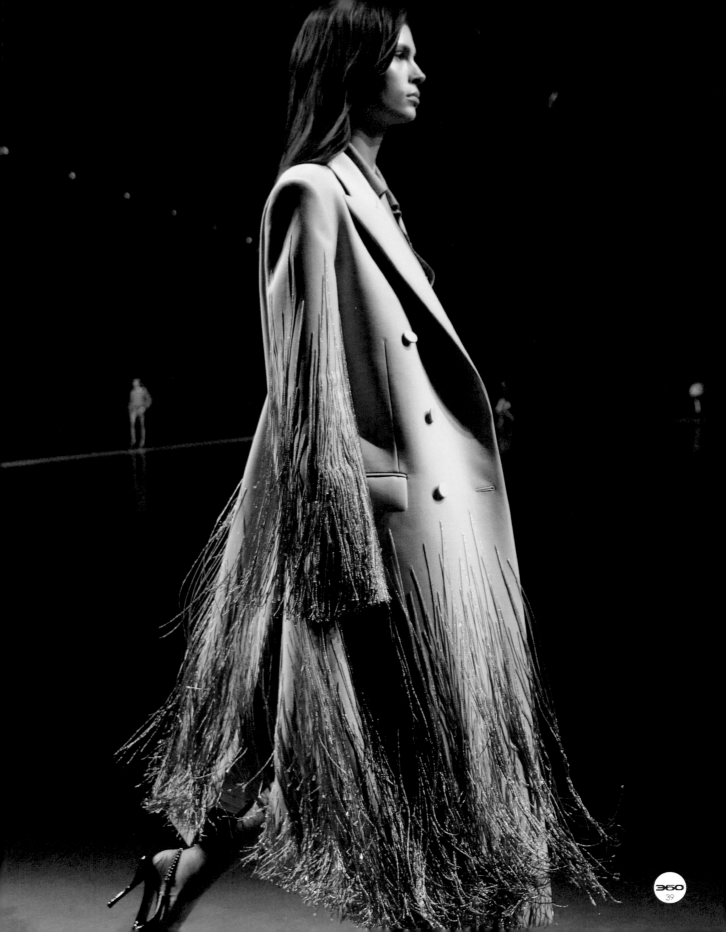

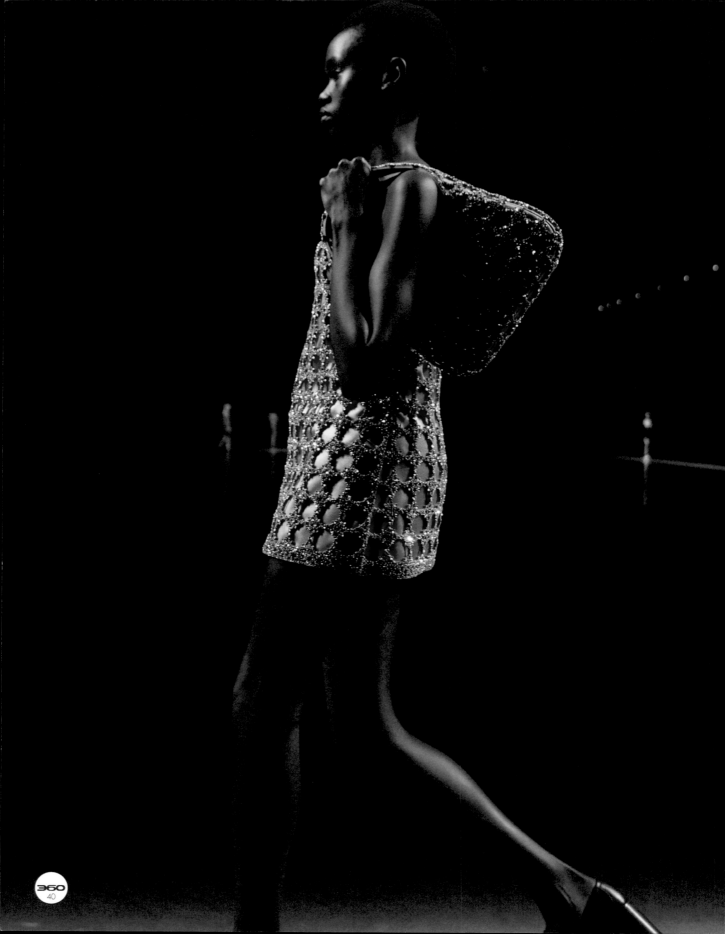

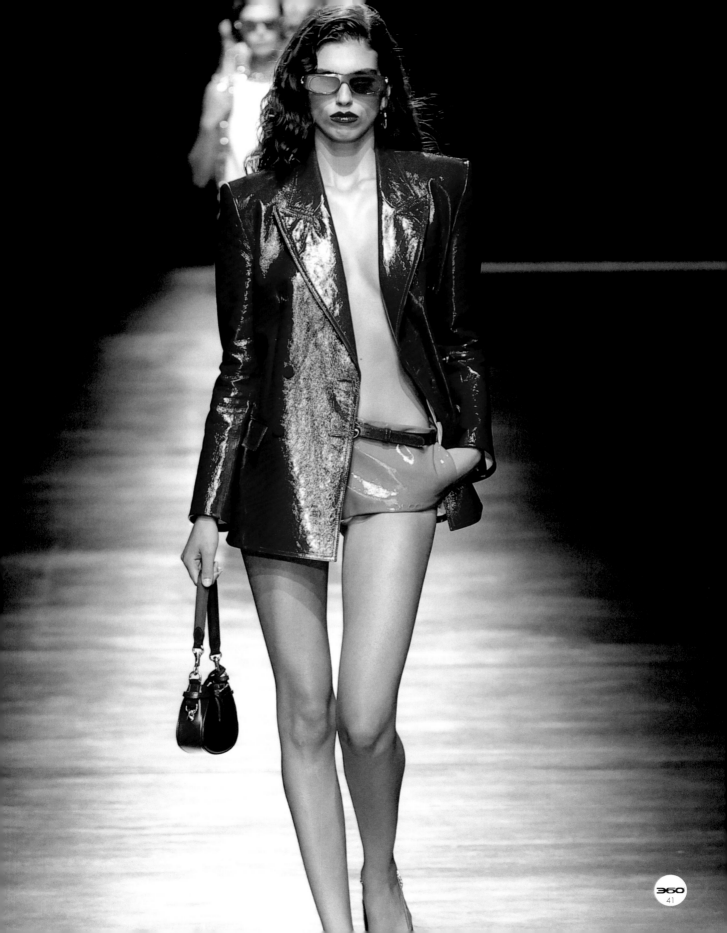

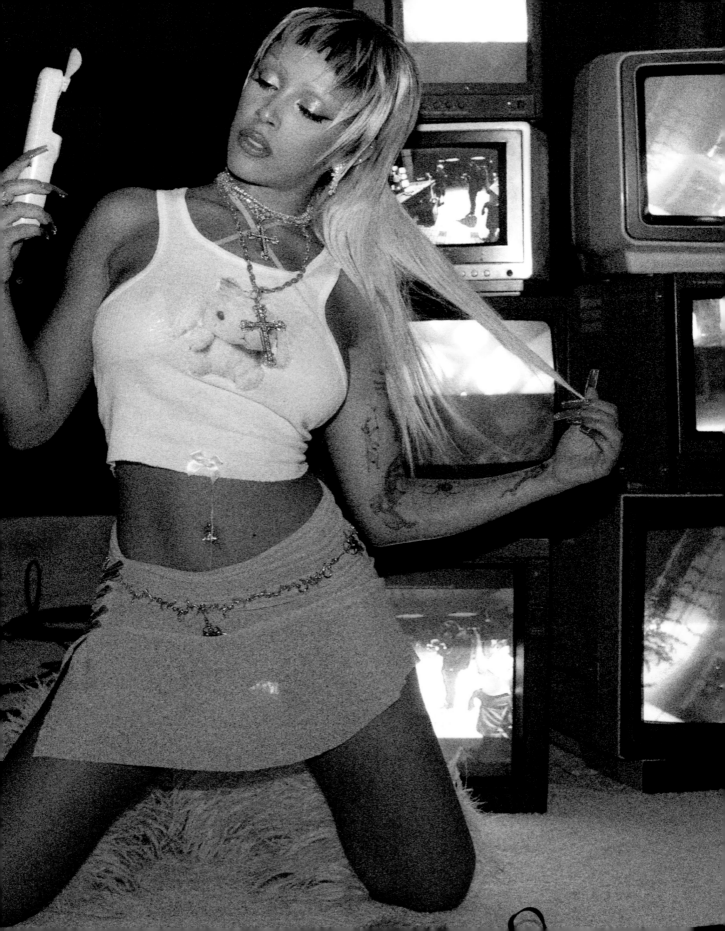

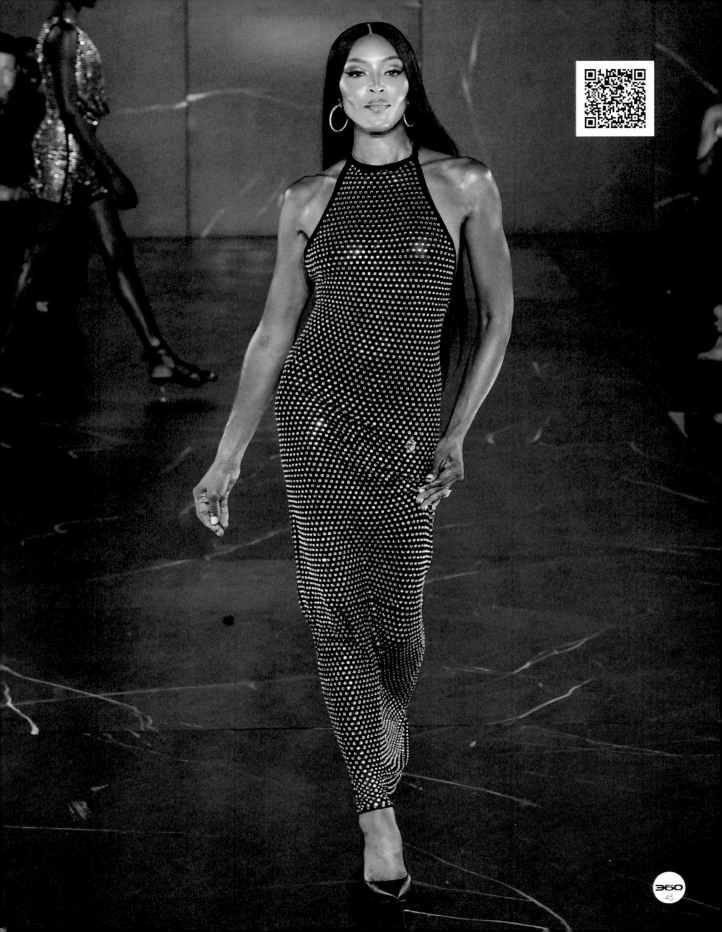

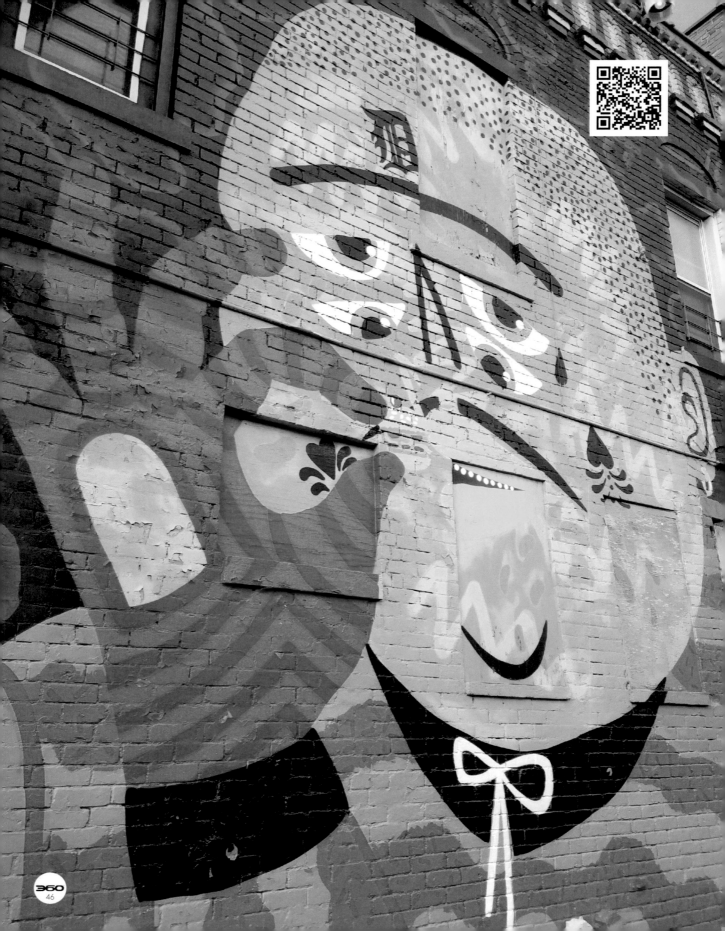

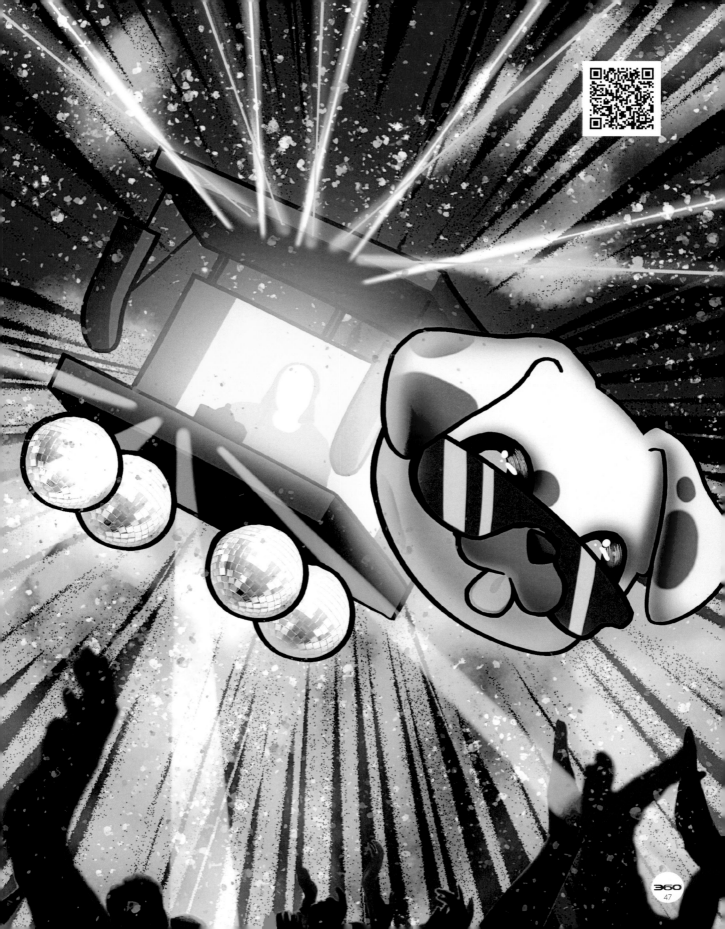

Milton Keynes UK
Ingram Content Group UK Ltd.
UKRC032114120224
437742UK00006B/128